Pooches In Shades

PUCCI BOOKS

For Leonard and Renée

Published by Pucci Books Ltd
120 Cowley Road
Mortlake
London
SW14 8QB
United Kingdom
www.puccibooks.com

Art Director, Illustration Design and Production
Rui Jiang

2008 2009 2010 2011 / 10 9 8 7 6 5 4 3 2 1

Cover image: Mia Feinstein

ISBN: 978-0-9559352-0-6

British Library cataloguing-in-publication data
A catalogue record of this book is available at the British Library

Pooches In Shades

Mia Feinstein

Foreword by Simon Pegg

PUCCI BOOKS

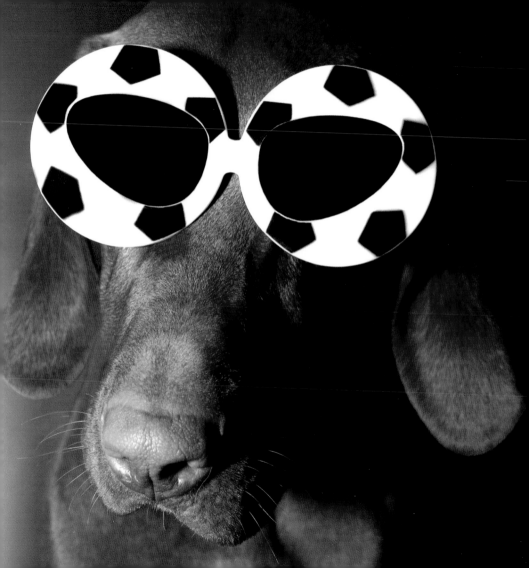

FOREWORD

I love Dogs. I used to fantasize about having one when I was small. We had cats, which are also lovely in their own slightly aloof way, but this meant the presence of a canine in the house could lead to tension. Families are sometimes tense enough, even if they're all one species. So I was restricted to walking the streets with my faithful, imaginary companion trotting along at my heel, which, however poignant, was also always fun. Recently, I suddenly realised I was 37 and was not bound by the restrictions imposed upon me in my earlier life. This epiphany immediately inspired myself and my wife to go out and get ourselves a dog. You will find her in the pages of this book.

Which brings me on to my other love: sunglasses. Ever since I bought my first pair of purple–glassed, John Lennon–style shades at The Glastonbury Festival in 1987, I have been a fan of tinted eyeware. Now, in my dog–owning adulthood, I have countless pairs. From Aviators to Wayfarers, contemporary to vintage, I love them all. How happy was I then, when I discovered that Mia Feinstein would be publishing a book of photographs combining two of my great loves. It's a joy when the universe throws two of your most disparate interests together and allows you to experience them in one place.

Here then is a collection of photographs that proves, very much, that the future is bright.

Simon Pegg 2008

P.S. I also love hats.

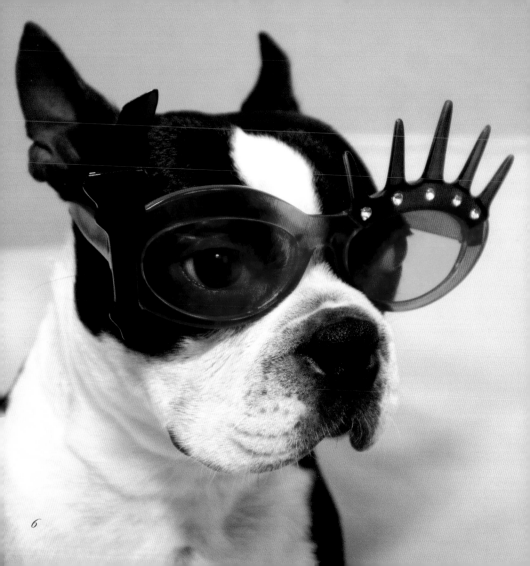

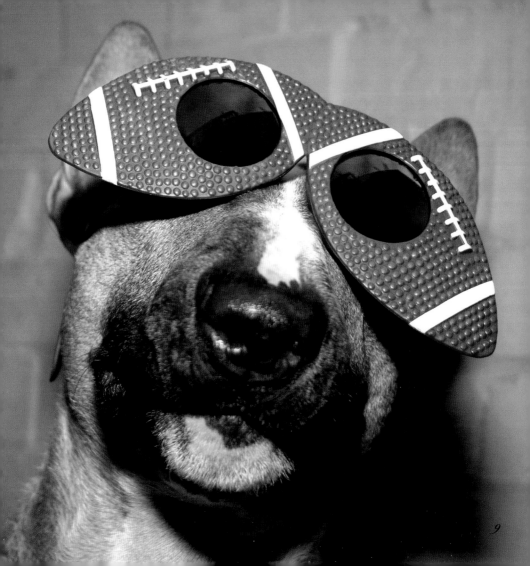

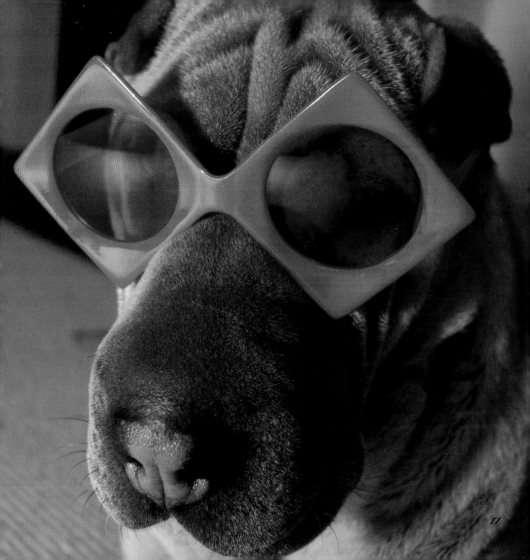

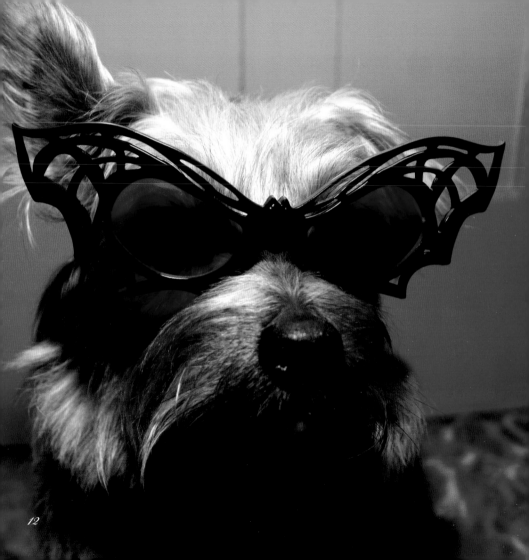

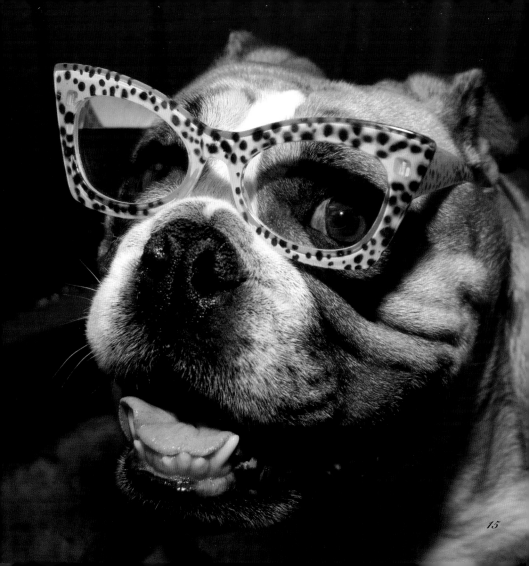

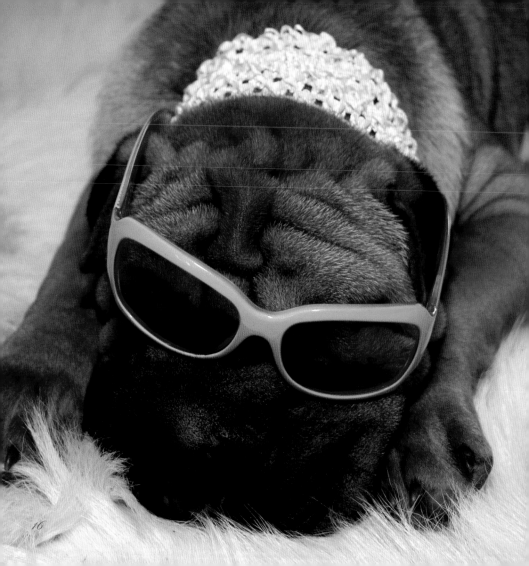

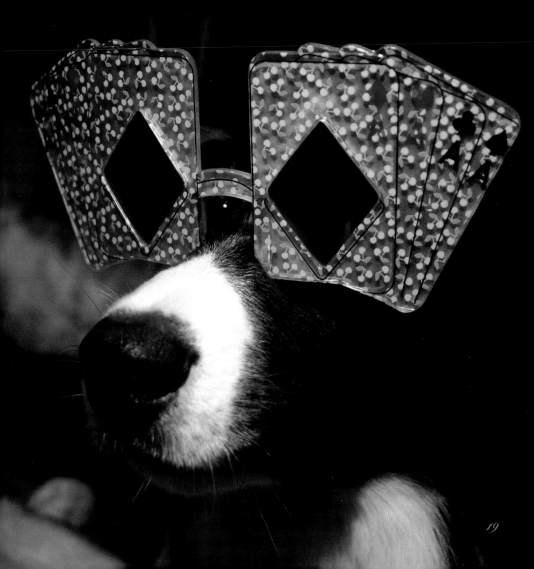

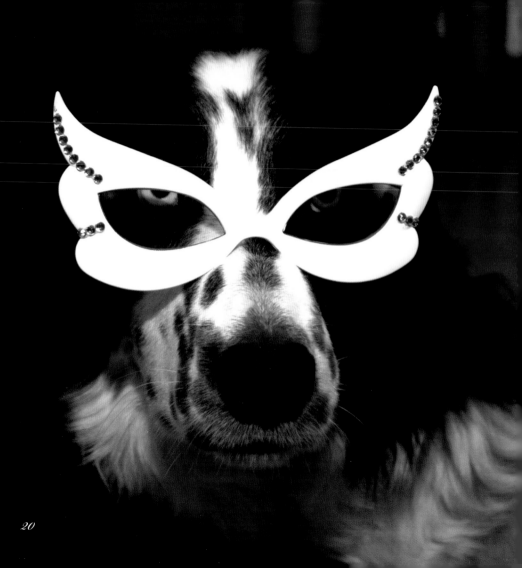

21

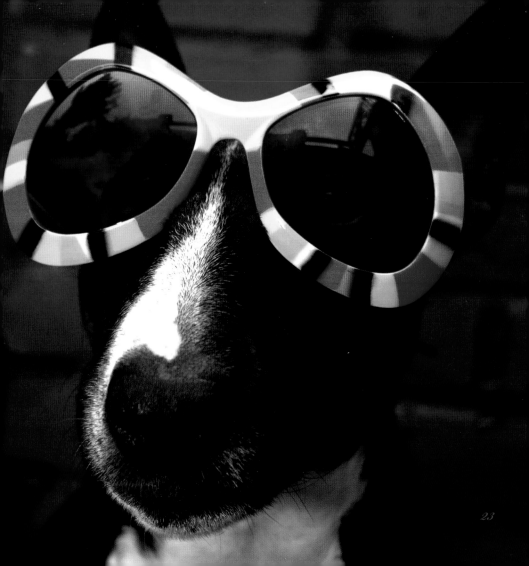

21

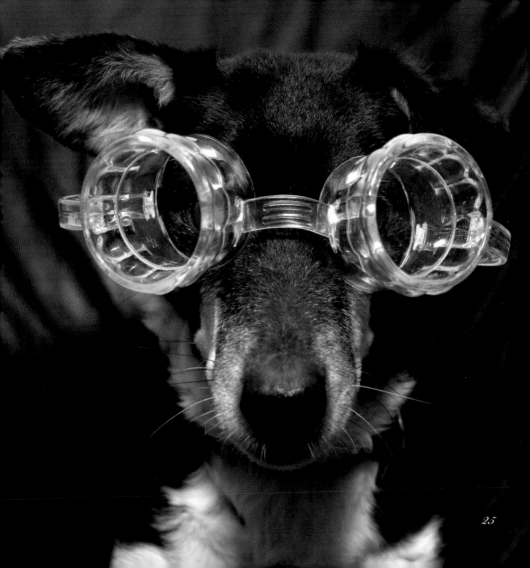

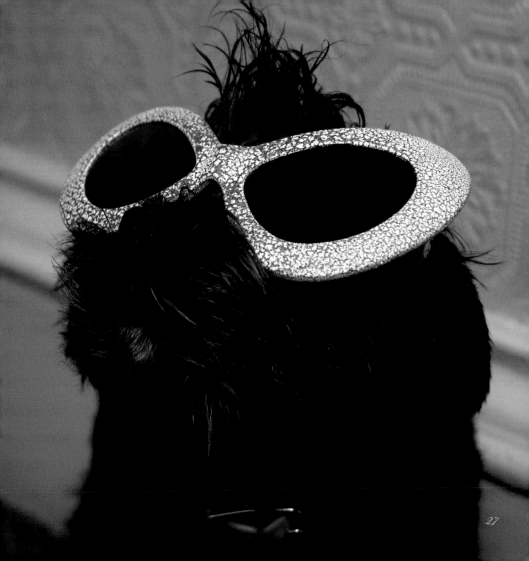

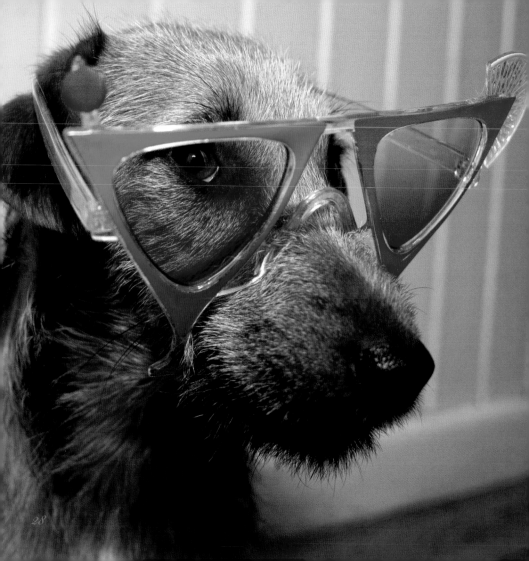

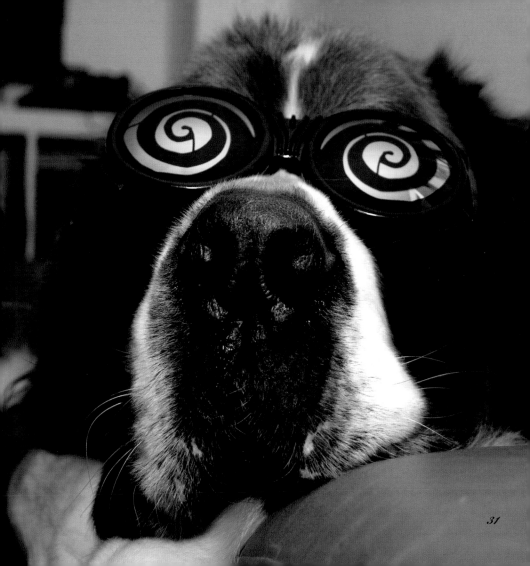

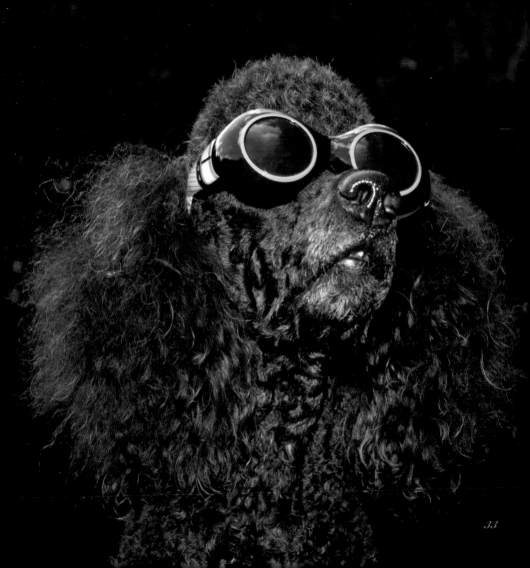

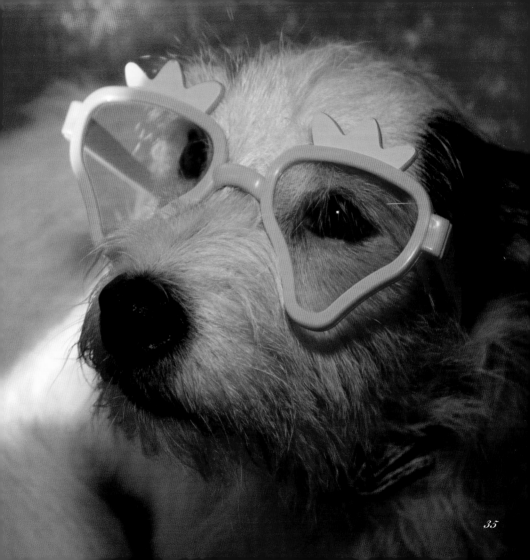

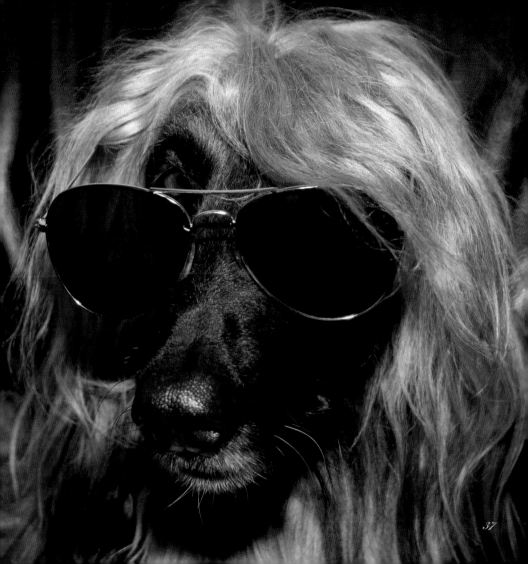

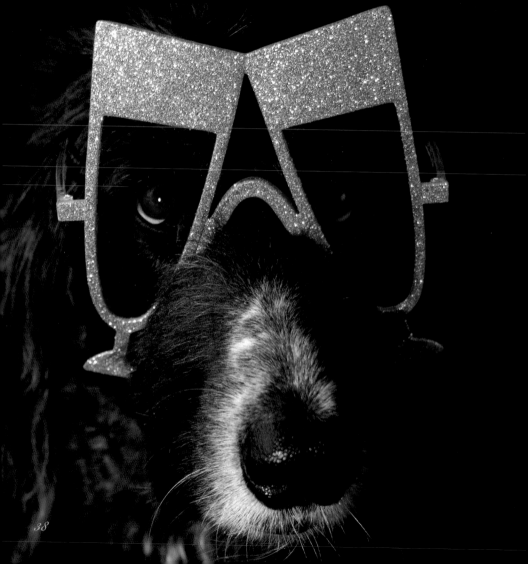

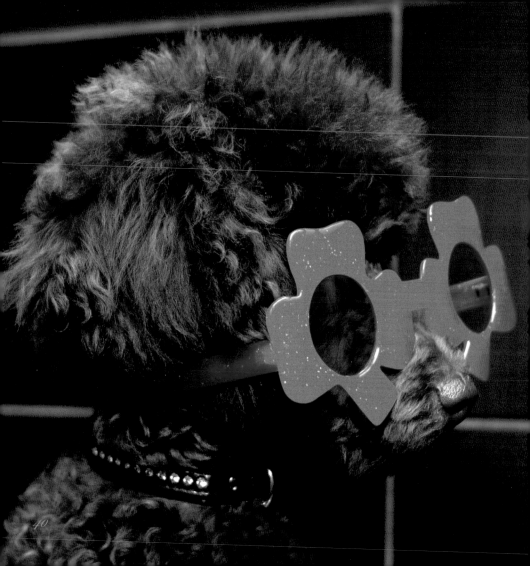

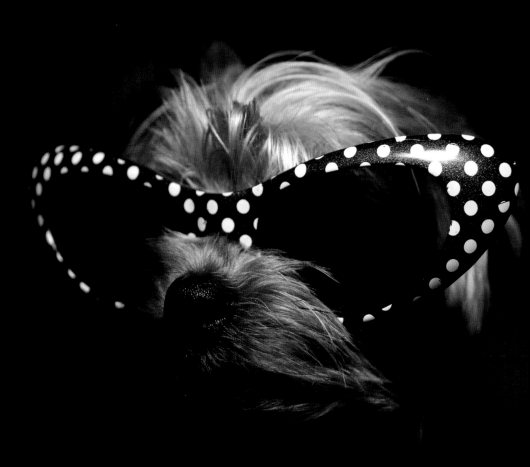

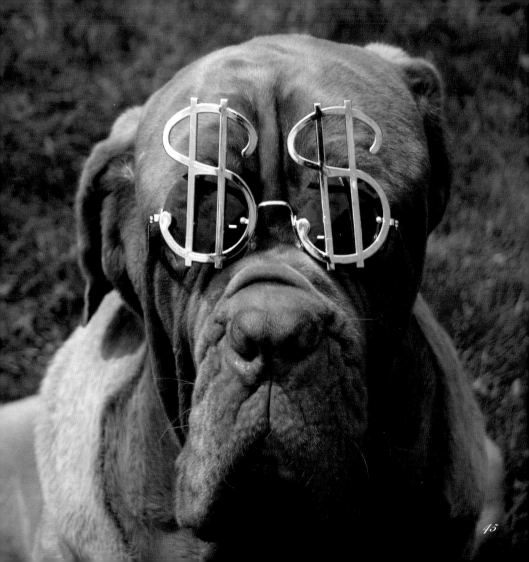

1 3 2 4 5 8 6 9 0 7

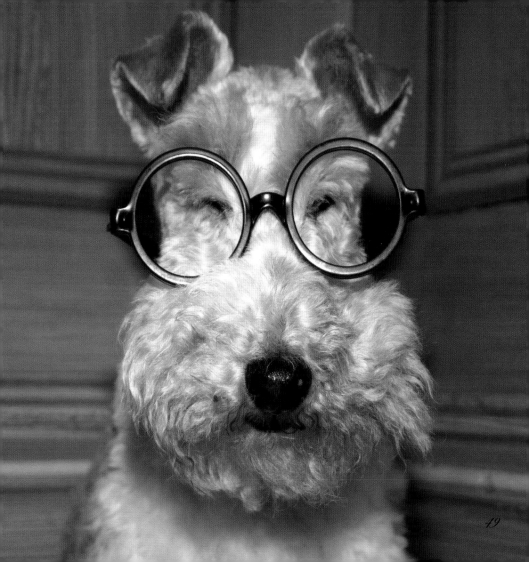

19

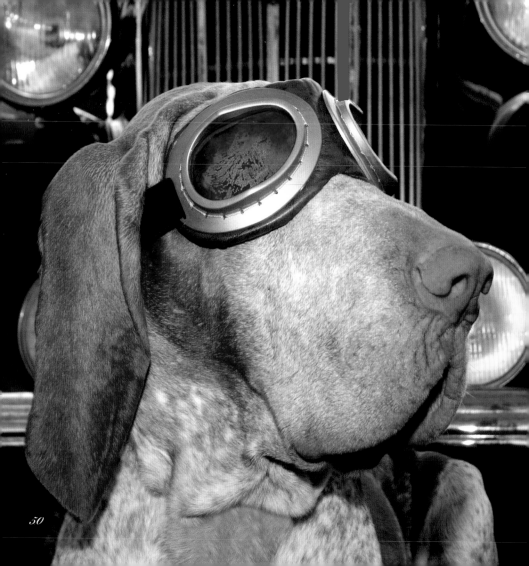

52

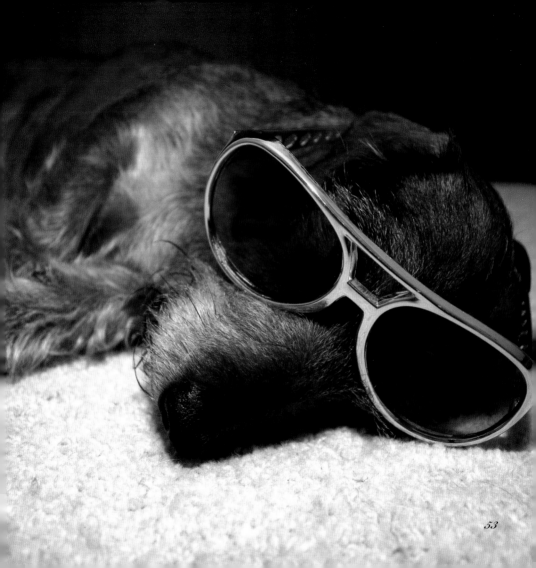

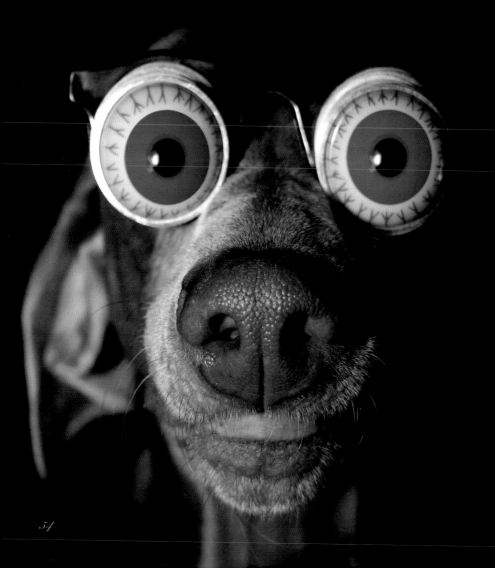

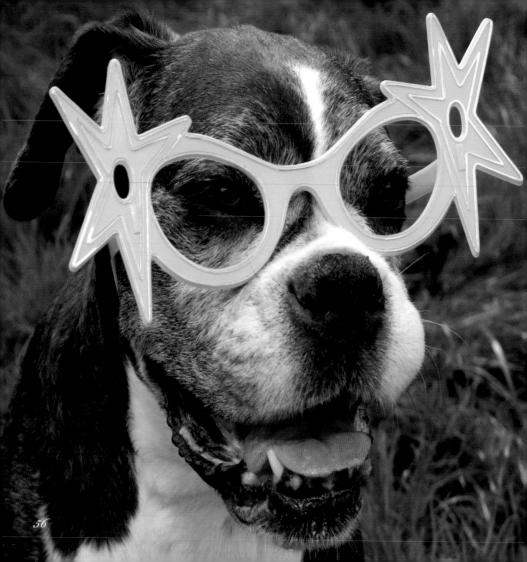

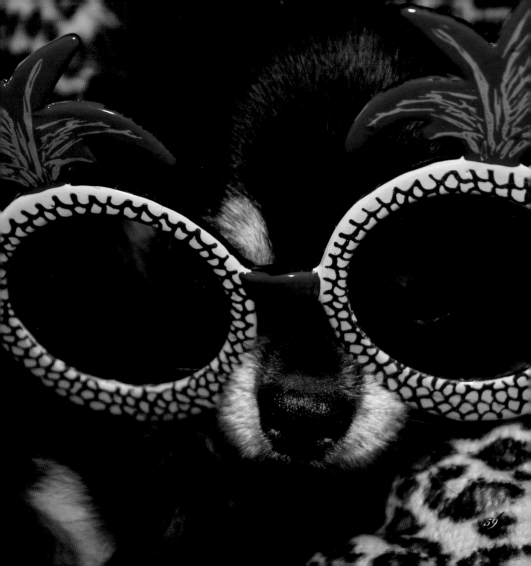

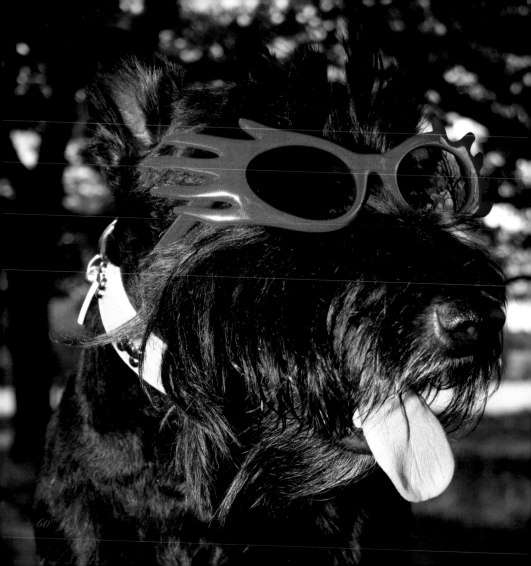

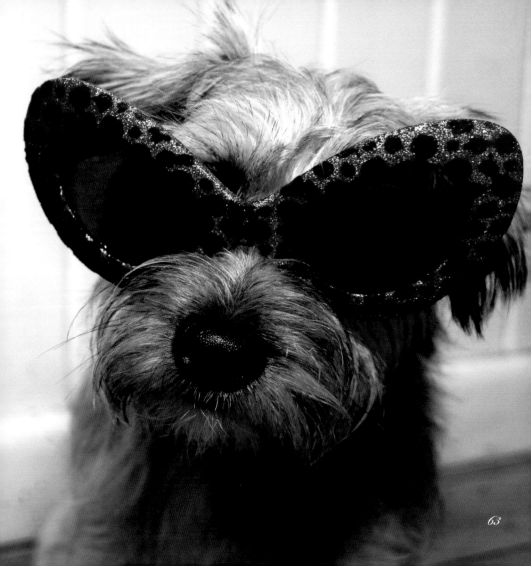

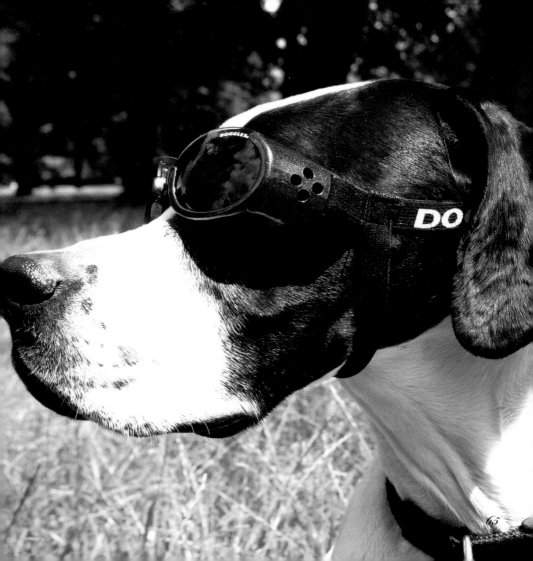

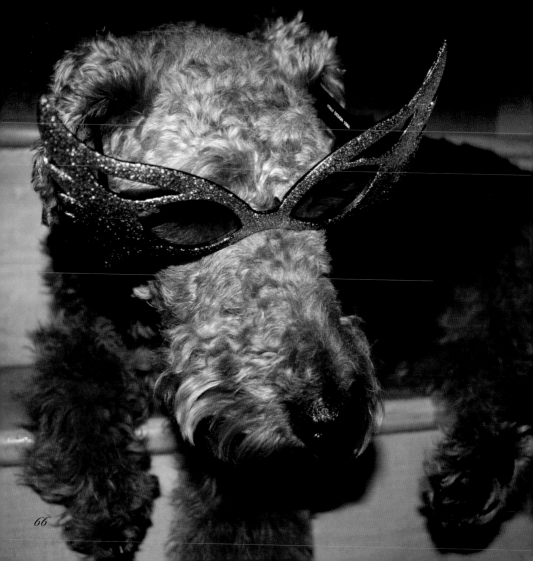

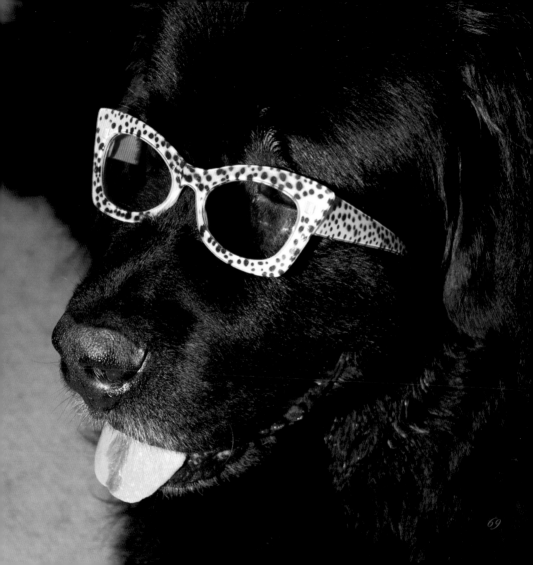

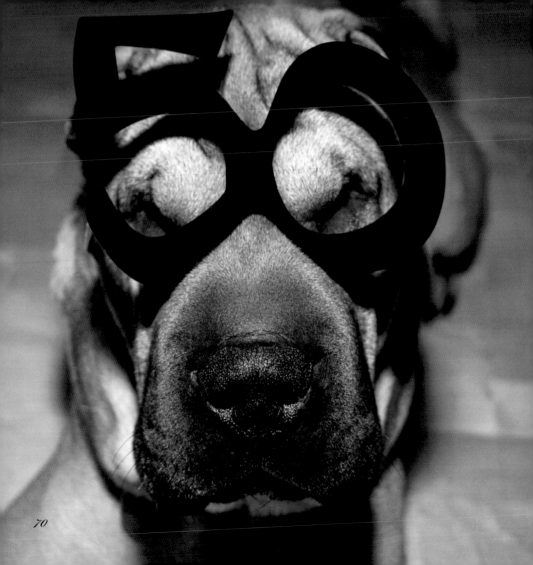

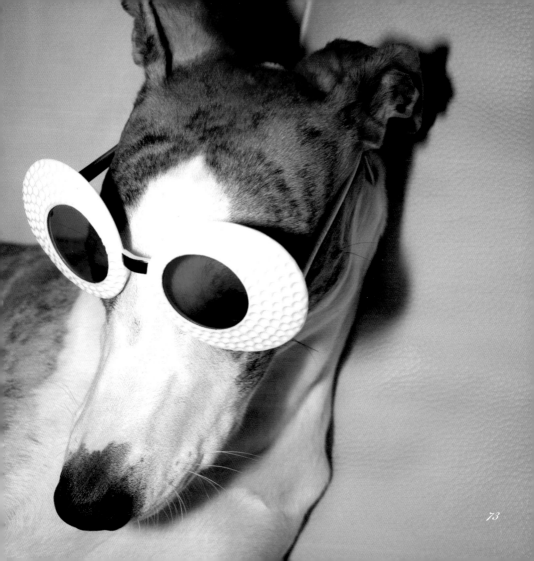

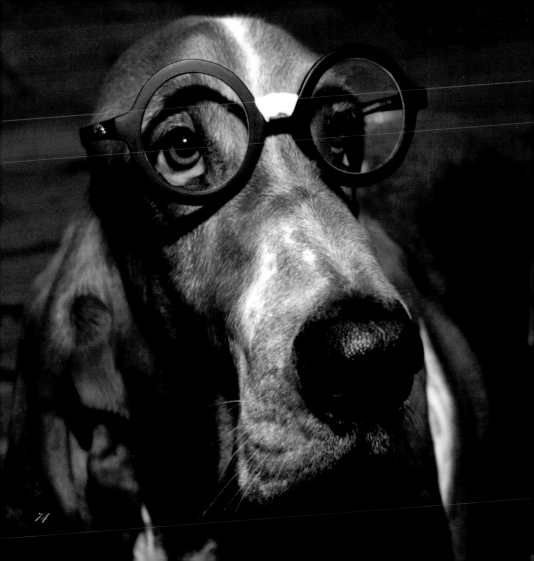

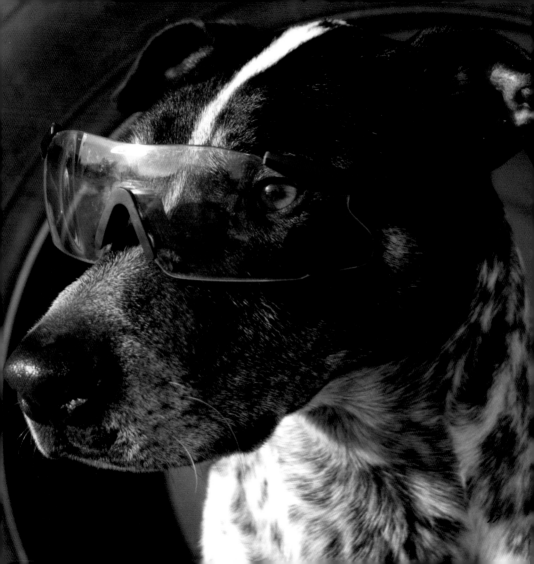

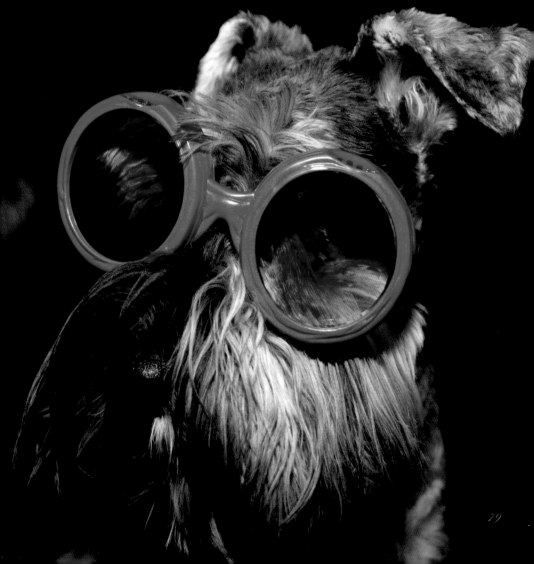

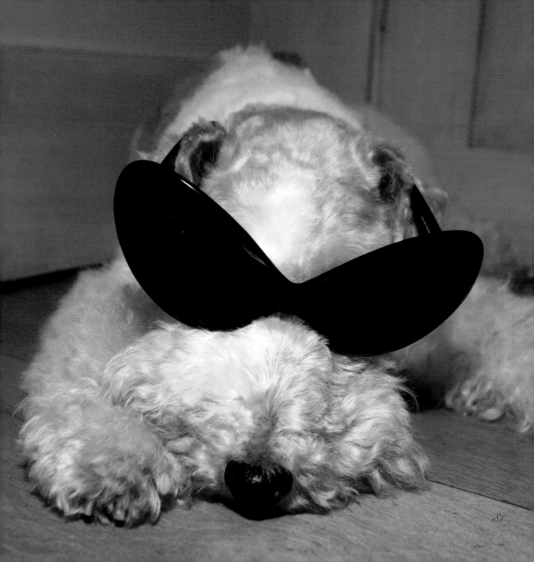

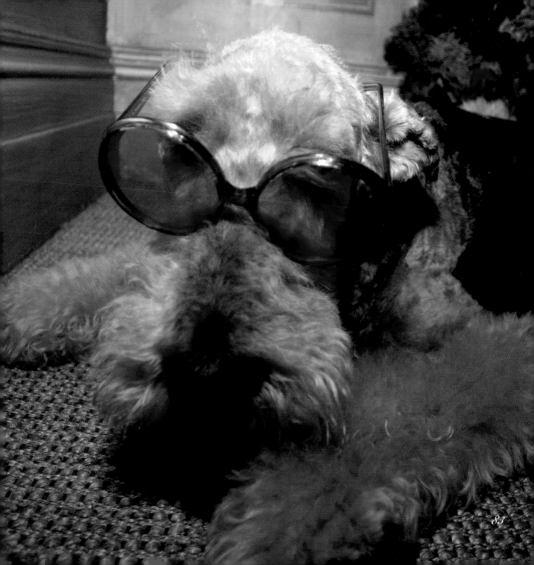

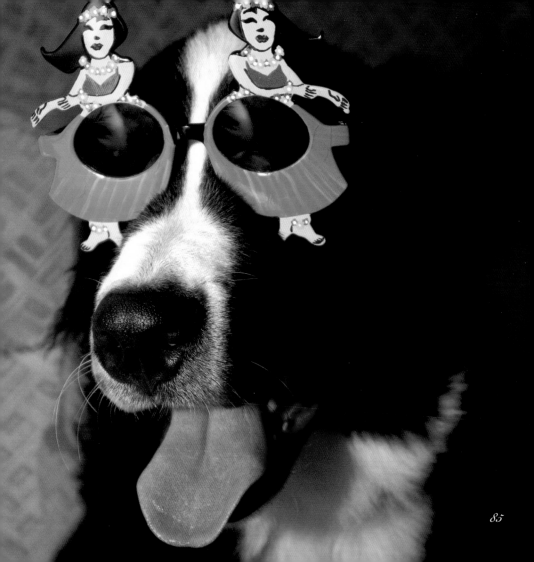

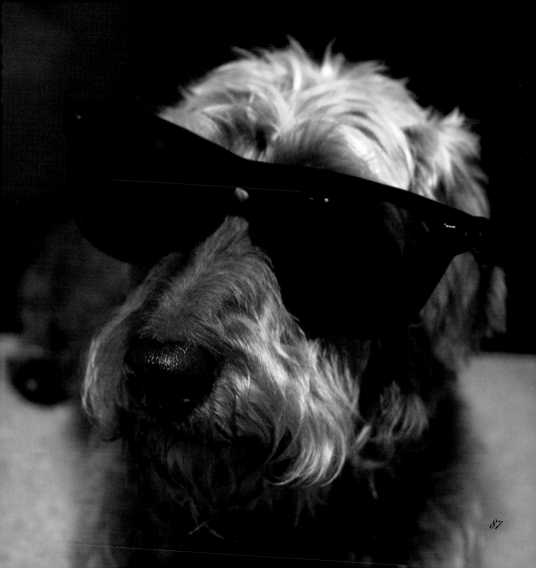

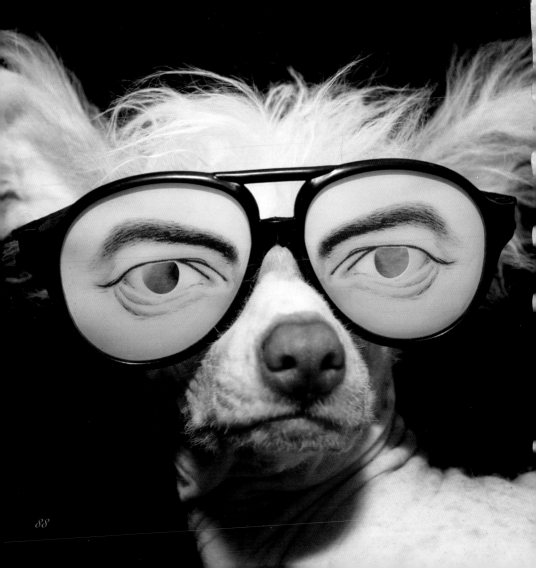

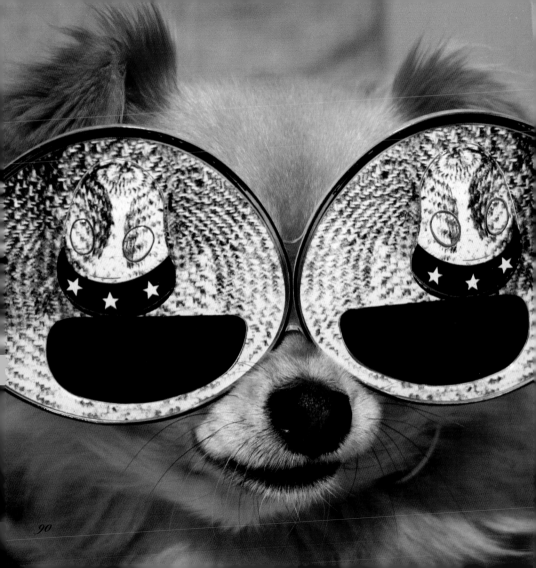

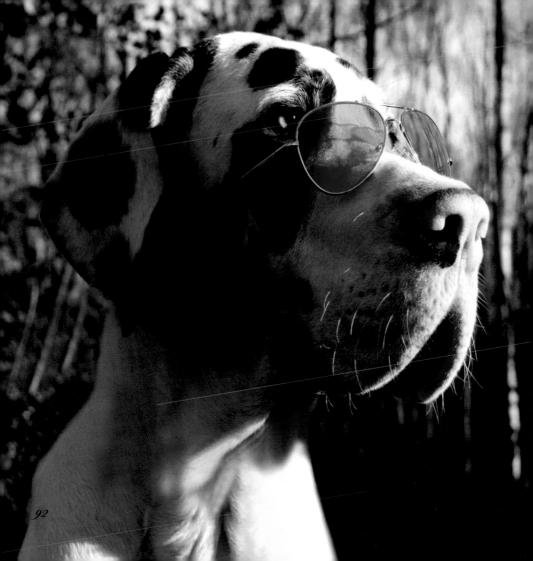

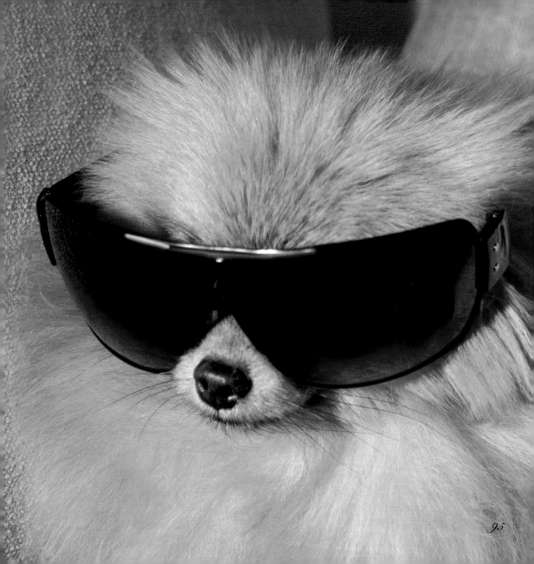

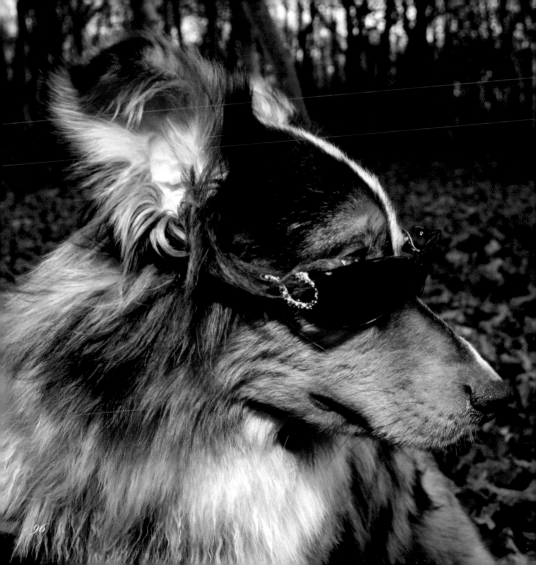

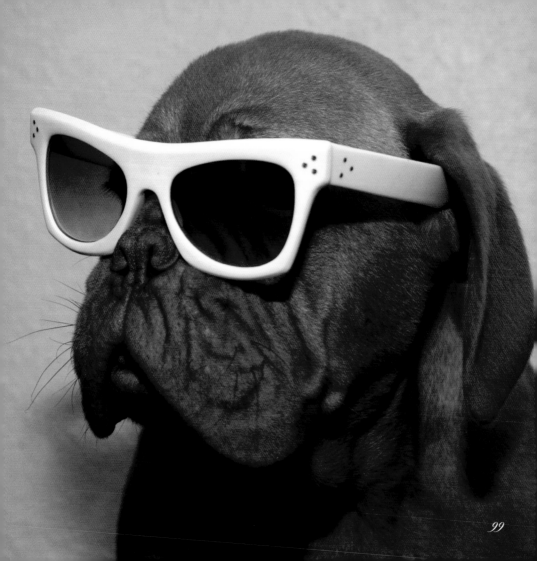

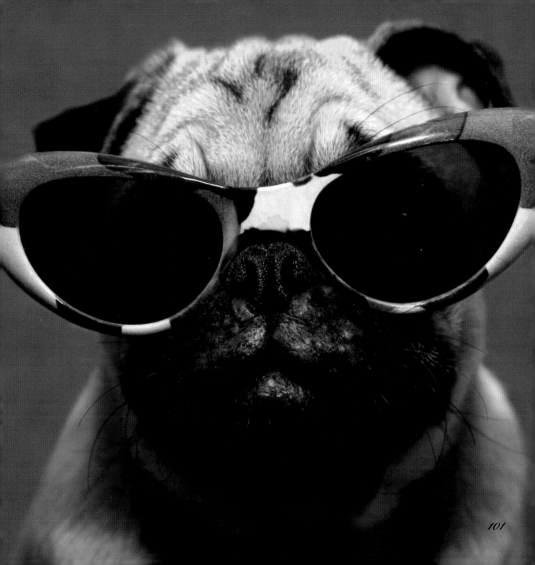

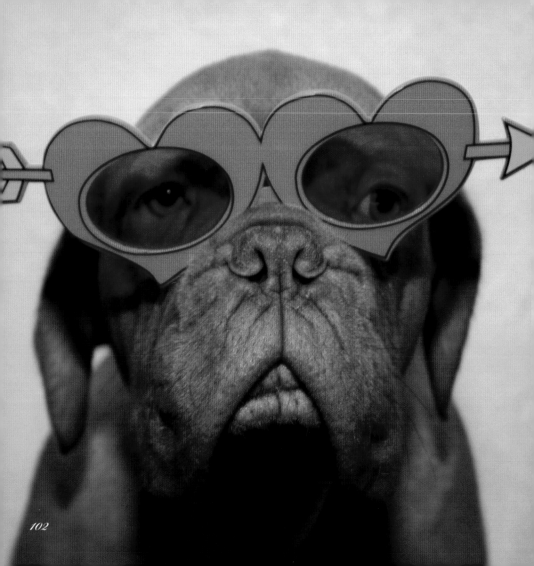

104

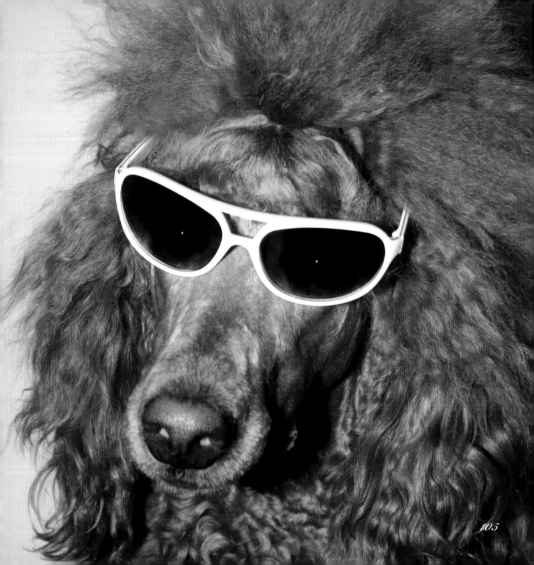

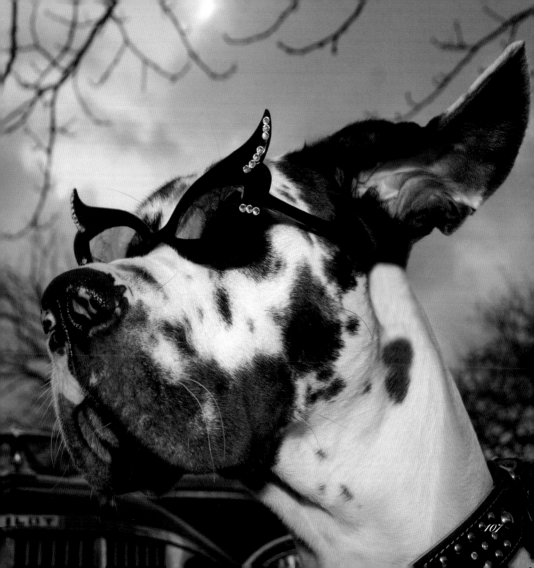

107

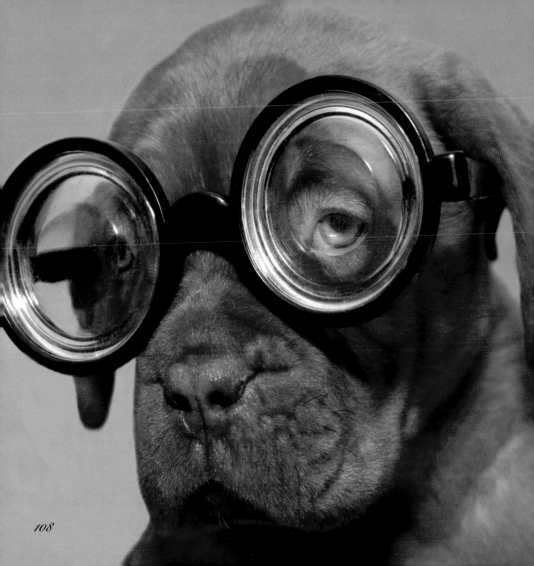